In the Footsteps of Jane Austen

through Bath to Lyncombe and Widcombe

A walk through history

by

Janet Aylmer

First published in Great Britain by
Copperfield Books, Hillbrook House, Bath BA2 4LS
in 2003.

ISBN 0 9528210 87

A CIP catalogue record for this book is available from the British Library.

Printed in Great Britain by Antony Rowe Limited, Chippenham, Wiltshire.

To

Sally

for whom history is a pleasure

Introduction

Jane Austen was the seventh child and the second daughter in the family of eight children of the Reverend George and Mrs. Cassandra Austen. She was born in 1775 and spent her first 25 years living in her father's rectory in the Hampshire countryside, with occasional visits to relatives and friends who lived elsewhere. Except when she was separated from her dear elder sister Cassandra (and when the letters she then wrote to her survive), little detail is available of how Jane Austen spent much of her time.

At the end of the year 1800, her parents decided, on her father giving up the living and the rectory that went with it, to return to Bath for his retirement. Jane's parents had been married in the city in 1764, and Jane's maternal uncle and his wife, Mr. and Mrs. Leigh-Perrot, had a residence there at No.1 The Paragon. Two previous visits to Bath by Jane and some of her family are recorded in 1797 and 1799, but a permanent move to the city was not welcomed by either Jane or Cassandra Austen, then aged 25 and 28. Bath in the early 1800s was past its period of greatest popularity as a resort for the visitor, and was becoming more a place of residence.

In 1810, the comments made by Louis Simond when visiting Bath perhaps explain why Jane Austen did not like the city, and preferred its rural surroundings -

"This town looks as if it had been cast in a mould all at once: so new, so fresh, so regular.

The building where the medical water is drank, and where the baths are, exhibit very different objects: human nature, old, infirm or in ruins, or weary and ennuyé. Bath is a sort of great monastery, inhabited by single people, particularly superannuated females. No trade, no manufactures, no occupations of any sort, except of killing time, the most laborious of all.

Half of the inhabitants do nothing, the other half supply them with nothings: Multitudes of splendid shops, full of all that wealth and luxury can desire, arranged with all the arts of seduction."

In May 1801, Jane Austen travelled to Bath with her mother to search for a place for the family to live, lodging with the Leigh-Perrots for a few weeks whilst they did so. It is the separation of Jane during this period from her sister, who was making a visit with their father to their brother Edward's house at Godmersham in Kent, that enables us to learn from her letters how she was passing the time during her visit.

Although busy hunting with her mother for a new home, Jane found time to escape from the confines of the town, then much smaller in extent than it is now. It may have been because Jane was not very fond of her aunt that she took every opportunity during her stay at The Paragon to get out of the city into the places nearby in the countryside. Or her interest in walking may just have been the continuation of her established pattern in Hampshire.

Whatever the reason, it is clear that Jane took the opportunity to walk out away from the centre of the city when she could, and also to take a carriage drive with friends for the same purpose when they offered to take her. Jane mentions outings to the Sydney Gardens, to Kingsdown some miles to the east, to the Kennet and Avon Canal (then under construction through the eastern side of the centre), to Weston, to Sion Hill, and a plan to visit the "Cassoon" on the Coal Canal at Combe Hay.

Once Cassandra had joined Jane in Bath, the letters cease, but references to Bath and the surrounding area in Jane Austen's novels give us further descriptions of the places which she knew and visited during her stay in the city between 1801 and 1806.

Jane had a Mrs. Chamberlayne as her walking companion during these first weeks in Bath. The "Brabourne Edition" of Jane Austen's letters states that the Reverend Thomas Chamberlayne, rector and patron of Charlton, had married in 1799 Maria Francesca, daughter of a Captain Robert Walter, R.N. As Charlton and Steventon were parishes not far apart in Hampshire, this perhaps explains their previous acquaintance. It seems that Jane Austen also knew Maria from elsewhere. A letter from Jane to her sister Cassandra from Bath, dated 5 May 1801, says ...

"The Chamberlaynes are still here. I begin to think better of Mrs. C----, and upon recollection believe she has rather a long chin than otherwise, as she remembers us in Gloucestershire when we were very charming young women.. The friendship between Mrs. Chamberlayne and me which you predicted has already taken place, for we shake hands whenever we meet."

In another letter, on 21 May 1801, Jane tells her sister of an outing to Weston, on the Bristol side of the city.

"Our grand walk to Weston was again fixed for yesterday, and was accomplished in a very striking manner.

Every one of the party declined it under some pretence or other except our two selves, and we had therefore a tête-à-tête; but that we should equally have had after the first two yards had half the inhabitants of Bath set off with us.

It would have amused you to see our progress. We went up by Sion Hill, and returned across the fields. In climbing a hill Mrs. Chamberlayne is very capital; I could with difficulty keep pace with her, yet would not flinch for the world. On plain ground I was quite her equal. And so we posted away under a fine hot sun, she without any parasol or any shade to her hat, stopping for nothing, and crossing the churchyard at Weston with as much expedition as if we were afraid of being buried alive.

After seeing what she is equal to, I cannot help feeling a regard for her. As to agreeableness, she is much like other people."

In a later letter, Jane tells her sister about a walk on Monday 25th May 1801, from her aunt and uncle's house in The Paragon to a pleasant area on the south side of the River Avon - to Lyncombe and Widcombe.

This is the walk that is the subject of this book.

"I walked yesterday with Mrs. Chamberlayne to Lyncombe and Widcombe...

Mrs. Chamberlayne's pace was not quite so magnificent on this second trial as in the first; it was nothing more than I could keep up with, without effort; and for many, many yards together on a raised path I led the way.

The walk was very beautiful as my companion agreed, whenever I made the observation.

And so ends our friendship, for the Chamberlaynes leave Bath in a day or two."

Letter from Jane Austen to her sister Cassandra
dated Tuesday 26 May 1801

To Lyncombe and Widcombe

To get to their destination, Jane and her friend would first have passed through the centre of the crowded city. Then there was the need to cross the River Avon in order to reach the open land beyond, where there were few buildings, and she could enjoy some of the rural views outside Bath.

Many buildings in the centre of the city, and parts of Lyncombe and Widcombe, remain now as Jane would have seen them. Other, earlier, features and activities in the locality had disappeared before she took her walk more than 200 years ago.

This book considers what Jane would have seen during her walk to Lyncombe and Widcombe, and compares activities in earlier years with the 19th century, and with more modern developments.

Once across the river, there are several ways that the two ladies could have chosen to walk. Since Jane Austen refers to "Lyncombe and Widcombe" and not to "Widcombe and Lyncombe", the route described in this book seems the most likely.

Contemporary illustrations have been used whenever possible to give an idea of what Jane and her friend would actually have seen. Many parts of the city and its immediate surroundings are little changed since the early 19th century, so readers of this book can, if they wish, retrace Jane's steps to visit Lyncombe and Widcombe as they are today.

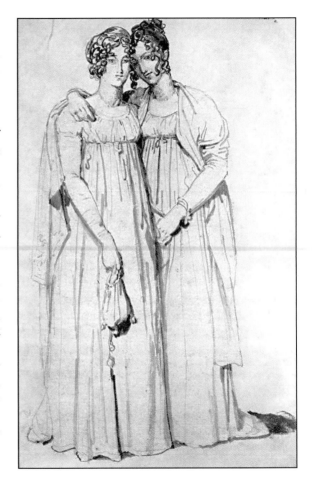

Lyncombe and Widcombe are just beyond the River Avon on the southern side of the centre of Bath. The history of the area, including remains dating from the Roman occupation, show that people have lived in Lyncombe and Widcombe for as long as they have in the better-known areas of the city.

In medieval times, vineyards, market gardens, and fishponds were established in the rural valleys by the Prior of Bath who was in charge of the Abbey, but who had his "country house" in Widcombe.

The attractive 16th century church of St Thomas à Becket is contemporary with Bath Abbey and, with the handsome house now known as Widcombe Manor, forms one of the most pleasant local scenes close to the city.

After the ownership of the land in the locality by the Church had ceased, local entrepreneur Ralph Allen built his handsome mansion, Prior Park, on the higher slopes above Widcombe, and used his long private carriage drive as a means of transferring the stone from his quarries on the hill at Combe Down to the River Avon, for transport on to Bristol and London.

A few years later, two large houses in the Lyncombe Vale were used as a sanatorium and a place for drinking the waters from the local spring; and as a pleasure garden - a popular location for residents and visitors wishing to make an outing away from the bustle of the city. Another local entrepreneur, Mr. Wicksteed, produced commemorative medallions in buildings close to Widcombe Mill in the same Georgian period, and a pleasure garden was opened later on that site also.

Although many more houses were built during the 19th century and since, the area still retains the attractive appearance which Jane Austen saw, and which was recorded by J. Tunstall in his "Rambles about Bath" (3rd edition, 1851) as follows:

"The Vale of Lyncombe has not changed; it is still beautiful; and Lyncombe Hill, another delightful walk by which it may be approached, presents, at every opening, unsurpassed views…"

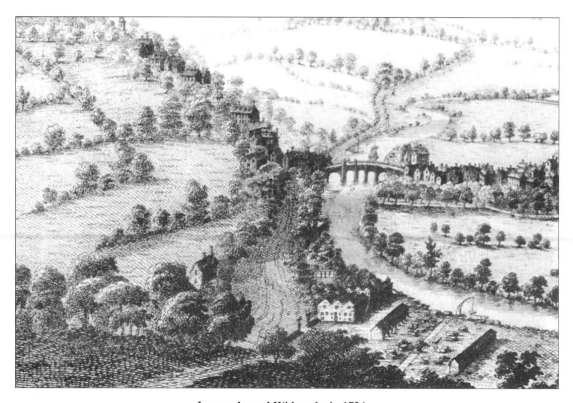

Lyncombe and Widcombe in 1734,
Looking to the west - with Holloway to the left of the old bridge,
the centre of the city of Bath on the centre right, and Ralph Allen's wharf in Widcombe at bottom right

Part One

From No.1 The Paragon

through
Broad Street and High
Street, past the Abbey
and the Pump Room,
to Orange Grove,
past North Parade,
then along
South Parade

to the Whitehall Ferry

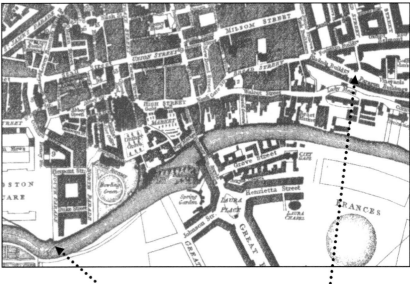

The Whitehall Ferry

No.1 The Paragon

We do not know where Mrs. Chamberlayne was staying, but the two young ladies may have started their walk from No.1 The Paragon, where Jane Austen had been living since the beginning of May with her uncle and aunt, Mr. and Mrs. Leigh-Perrot.

The Paragon was (and is) one of three terraces of Georgian houses in a row in this street on the north side of the city centre. Facing a busy road, the house might not seem to be the best choice by Mr. Leigh-Perrot and his wife for their Bath home.

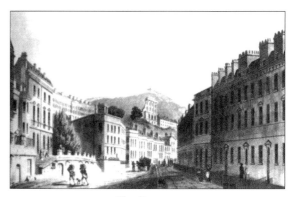

The Paragon

The route was part of a main road eastwards out of Bath, and we may imagine the busy stage coaches passing the door, including the London mail.

However, with the fall in the ground southwards, the house has a pleasant outlook at the rear. Perhaps gazing over those views, if Jane's room was at the back, encouraged her to plan her frequent outings to the more rural areas beyond the city limits.

The house is also a short walk from the Upper Assembly Rooms (as they were then known) in Bennett Street, the good choice of shops in Milsom Street, and the markets in High Street, as well as being close to the fashionable residential streets such as Lansdown Crescent and Camden Crescent in the Upper Town.

The proximity of these urban amenities may not have impressed Jane Austen, with her dislike of city life, but they would have made everyday living in Bath more practical for her uncle and aunt.

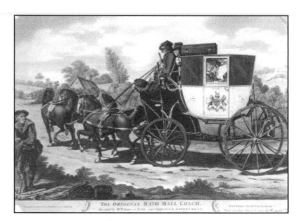

The Bath mail coach

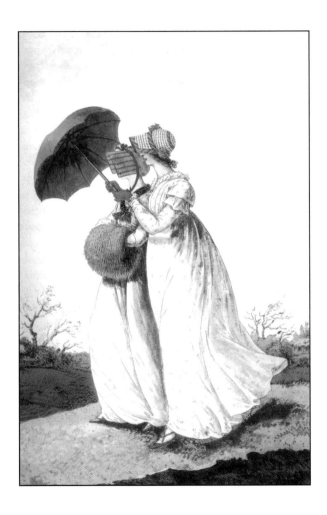

Walking Clothes

We know from her letters and her novels that Jane Austen was interested in clothes and current fashions.

In the early 1800s, women's day dresses had a high waistline, a straight silhouette and long sleeves, and were made in light coloured soft fabrics.

Sometimes dresses had an "underskirt", intended to be seen, with the over-dress parted at the front to show the fabric beneath.

Many ladies wore shawls, or the "pelisse" (a jacket or cloak with sleeves). Fashionable bonnets at this time had a deep funnel brim, and were made of straw or fabric with ribbon and other trimmings.

(Some ladies who were not very wealthy made their own dresses. We know that Jane Austen used seamstresses; she chose fabric for dresses herself - usually 7 yards or so - and trimmings for bonnets.)

Since it was not fashionable for ladies of quality to become tanned, it is probable that Jane and Mrs. Chamberlayne would each have carried a parasol to shield them from the sun.

For walking to a rural area such as Lyncombe and Widcombe, the light shoes that ladies wore for town use were not suitable.

It is likely that Jane Austen and her friend would have put on "half boots", made of leather or the fabric called nankin.

The Paragon was in a residential street towards the top of the town, with No.1 on the southern side of the road facing Hay Hill and, a little to the west, the Countess of Huntingdon's Chapel (now used as the interesting Building of Bath Museum).

The most likely route for Jane and her companion to reach Lyncombe and Widcombe would have been to begin their walk westwards, past Bladud Buildings, towards the centre of town in order to cross the River Avon.

At the crossroads after 200 yards, their route lay to the left, down Broad Street. Immediately beyond the junction, and also on the left, was the popular and busy coaching Inn then known as the York House Hotel, which as the York Hotel still offers accommodation to travellers today.

The York House Hotel

Designed by the architect John Wood the Younger, the future Queen Victoria stayed at the York House in 1830, when she visited the city as a young girl with her widowed mother, the Duchess of Kent.

At the rear of the hotel is a car park, but the stables used in Jane Austen's time can still be seen beneath the rear façade of the building.

The appearance of Broad Street may not differ very much now from what Jane saw, but at the time of her walk there was a "rabbit warren" of tiny courts, fronted by mean-sized houses, behind the facades on the east (left hand) side of the street

Broad Street looking south

4

Further down the street, Jane would have seen on her right the handsome Palladian building of the Royal Grammar School. The free school was founded by King Edward VI in the 16th century, and he gave large parts of the city to the school to support it.

However, the city councillors, as trustees of the school, appropriated much of the endowment, so that before the Broad Street building was constructed, the boys had learnt their lessons in part of the old church (St Mary's) by the old North Gate, with prisoners in the gaol as their (surely unsuitable) neighbours.

Eventually, the then schoolmaster took the Council to court, and action was taken to remedy the situation.

The handsome building in Broad Street was erected in the mid 1700s on the site of an inn, The Black Swan.

The school remained there until towards the end of the last century, when the senior boys moved out first, to a new complex at North Road in Bathwick, followed by the junior school in the 1980s.

However, we can imagine Jane hearing the cries of the boys playing in the yard at the rear of the building as she passed by.

Broad Street gets its name from its width, which at the time exceeded that of many other roads in the city.

An area to the rear of the street on the west side was used by clothiers to dry their dyed and washed cloth on racks called tenters, kept taut by tenter hooks.

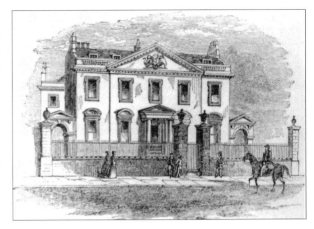

The Royal Grammar School

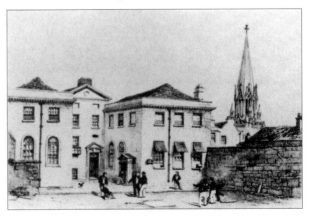

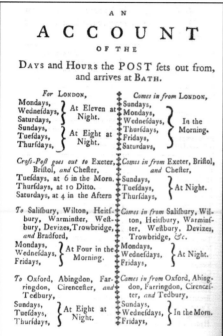

AN

ACCOUNT

OF THE

DAYS and HOURS the POST sets out from,
and arrives at BATH.

For LONDON,		Comes in from LONDON,	
Mondays, Wednesdays, Saturdays,	At Eleven at Night.	Sundays, Mondays, Wednesdays,	In the Morning.
Sundays, Tuesdays, Thursdays,	At Eight at Night.	Thursdays, Fridays, Saturdays,	

Cross-Post goes out to Exeter, Bristol, and Chester,		Comes in from Exeter, Bristol, and Chester,	
Tuesdays, at 6 in the Morn. Thursdays, at 10 Ditto. Saturdays, at 4 in the Aftern.		Sundays, Tuesdays, Thursdays,	At Night.

To Salisbury, Wilton, Heitsbury, Warminster, Westbury, Devizes, Trowbridge, and Bradford,		Comes in from Salisbury, Wilton, Heitsbury, Warminster, Westbury, Devizes, Trowbridge, &c.	
Mondays, Wednesdays, Fridays,	At Four in the Morning.	Mondays, Wednesdays, Fridays,	At Night.

To Oxford, Abingdon, Farringdon, Cirencester, and Tedbury,		Comes in from Oxford, Abingdon, Farringdon, Cirencester, and Tedbury,	
Sundays, Tuesdays, Thursdays,	At Eight at Night.	Sundays, Wednesdays, Fridays,	In the Morn.

Further down Broad Street on the right is a building at No.8 now housing the Postal Museum. This was the city's Post Office for more than 30 years until 1854, and the first letter with a stamp, the Penny Black, was sent from this building.

The comprehensive postal service was begun by Ralph Allen, organising cross-posts to link different parts of the country, with the mail carried on horseback by riders in relays. Later John Palmer pioneered the mail coach service to reduce transfer times.

Born in Bath in 1742, Palmer persuaded the government in 1784 to trial a mail coach with armed guards on the busy London-Bath-Bristol route, using the new turnpike roads without being delayed for paying the tolls.

The success of the trial led to expansion of the system throughout the country. Later John Palmer became the member of Parliament for Bath; he died the year after Jane Austen, in 1818.

Further down Broad Street on the left, beyond the modern Saracen Street, is the traditional style Saracen's Head public house, which was in existence at least as early as 1713. Charles Dickens, the Victorian novelist and writer, was one of its many patrons.

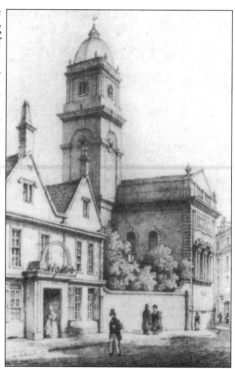

The Saracen's Head

At the bottom of Broad Street on the left, at the junction with Walcot Street, is St Michael's Church.

This is not the building that Jane would have seen in 1801. An older church (right) regarded as too old fashioned had been replaced in 1734 by the building that Jane would have seen, in a style chosen by the then churchwarden, Mr Harvey. That church was described by the architect John Wood as being in

Old St Michael's Church

> *"a taste so peculiar to himself (Mr. Harvey) that the very journeymen workmen to mortify him said that a horse, accustomed to the sight of good buildings, was so affrighted at the odd appearance of the church that he would not go by it until he was hoodwinked".*

Wood's comments may, of course, have been inspired by the rejection of his own design for the church by the vestry committee. However, another visitor to Bath, Pierce Egan, was of the view that the church "was an annoyance to admirers of architecture in Bath". Mr. Harvey's church was replaced in 1835 by the current structure.

In Jane Austen's time, the well-known Bear Hotel stood some distance to the west near Green Street; it was the terminus for coaches bringing travellers, like Jane and her family, from Salisbury and Devizes. From there, it would have been only a short walk to the Leigh-Perrot's house in The Paragon.

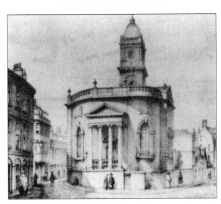

St Michael's Church (built in 1734)
This church was, in it's turn, replaced in the mid 19th Century.

From the bottom of Broad Street, we can see the Guildhall in the <u>High Street</u> ahead of us on the left.

In between, until 1755, was the site of the North Gate. Said to be about ten feet wide, this was the entrance to the city for visitors from London and the north. As already mentioned, the Grammar School was located in the old city walls, in the church of St Mary-by-Northgate (on the right in the picture) until the building in Broad Street was constructed.

The central part of the present Guildhall (the wings were added later) was built between 1775 and 1777 to replace the previous building, which had been in the centre of the High Street, above the open-sided market, and had been a considerable obstruction to traffic.

Part of the new Guildhall was set aside for the markets. The "Improved Bath Guide" describes these in enthusiastic terms -

> *"Here can be found a good supply of fish, flesh and fowl, and every other kind of provision at moderate prices: fresh butter, to any in England, is brought from the country every morning: and the butchers who live in the city supply the inhabitants with the best of meat every day of the week".*

The market still operates in the building today, and you can walk through to look at the stalls. Opposite the Guildhall, the street was lined with inns at the time of Jane's visit.

North Gate and St. Mary-by-Northgate

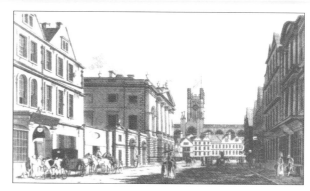

The new Guildhall (left) in the High Street, with the Abbey beyond

Bath Abbey lies ahead beyond the Guildhall and now, as in Jane Austen's time, is one of the famous sights of Bath. The present building replaced a much older Norman structure, and it's construction began in about 1500.

After the dissolution of the monasteries by King Henry VIII in 1539, the church came under the control of the city council in its unfinished condition.

In 1574, Henry's daughter Queen Elizabeth I visited the city and was very concerned about the state of the Abbey. She ordered that a national collection of money be taken to make the building fit for use, and closed all the other churches within the city walls, to make sure that the citizens used the Abbey.

By the time that Jane Austen and her companion passed by, the north side of the Abbey had been obscured by houses and shops.

Our two pictures show the change that was achieved once the buildings were removed.

The two young ladies would not have recognised the flying buttresses and the pinnacles; the buttresses were added in the 19th century by local architect G. P. Manners to add stability (and the pinnacles as decoration).

The buttresses were further strengthened in the early 1900s after the stone vaulting had been added to the ceiling of the nave.

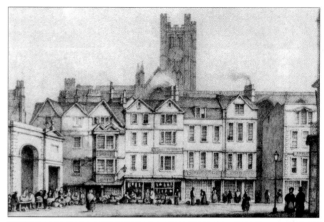

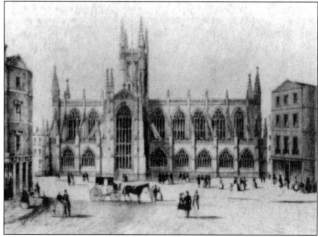

The area to the north of the Abbey, now hard surfaced and taken over by the motor vehicle except for a central flower bed, is <u>Orange Grove</u>, named after the Dutch prince who visited Bath in 1734.

In Jane Austen's time, the Grove was an open space with gravel walks bounded by shops and lodging houses.

In the middle 18th century, Mrs. Wicksteed had a shop there selling seals, and we shall find out later (in Part Three) where those were made.

Jane and Mrs. Chamberlayne would have been able to walk through the pleasant area at the east end of the Abbey shown in this 1805 print, rather than what we see now.

At the west end of the church is the carved stone ladder with angels both on their way up and down, showing the vision which inspired Bishop Oliver King to begin building the church. The carving of an olive tree encircled by a crown represent his name, and the bishop's mitre records the office that he held.

The traveller Celia Fiennes described the scene 100 years before Jane Austen was there -

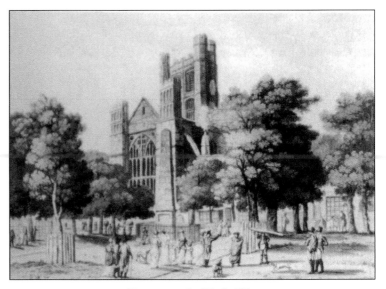

The east end of Bath Abbey

"..out of the Cathedrall you walk in to the Priory which has good walkes of rows of trees which is pleasant: there are deans, prebends and doctors houses which stand on that green, which is pleasant by the Church called the Abby which is lofty and spacious, and much company walke there especially in wet weather."

10

To make a short diversion to the west side of the Abbey, Jane would have seen the Pump Room.

We know from Jane Austen's letters that she was not keen on the formal social activities that Bath offered, but the <u>Pump Room</u> (rebuilt between 1791 and 1795 to accommodate more visitors) was also a place for people to meet each morning, and to gossip after taking the waters, before returning to their lodgings. Outside the Pump Room, the sedan

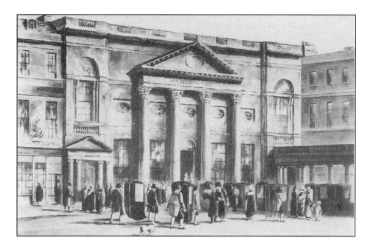

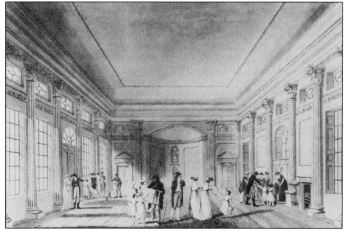

chairmen would wait for their "fares" - this illustration (left) shows one of the chairs used to carry their customers.

The advantages claimed for taking the waters at the Pump Room (as well as at the Hot Bath and the Cross Bath) had been the foundation for the success of the spa in the 18th century as a resort for invalids, and for visitors in better health.

The excavations for the new building in 1790 had revealed some roman remains some 12 feet below the surface, but it was not until towards the end of the following century that the full extent of the Roman Baths was revealed, and the Victorians created the appearance of the Roman Baths that we see today.

Returning to the east end of the Abbey, Jane and her companion would next have passed by the Lower Assembly Rooms near to the River.

The Lower Rooms were used for regular balls and assemblies; although Jane disdained such city pleasures, we know that she enjoyed dancing, and she referred to the Lower Rooms in her letters.

The Rooms had a chequered history.

First opened in 1730, and very successful in the early years, they suffered from strong competition after 1771 from the more modern Upper Assembly Rooms, which we shall pass later in our walk (in Part Four).

The Lower Rooms had gardens (known as St James' Triangle) with a bowling green below the building and adjoining the river bank. The open landscaped area by the River Avon has survived, and is now known as Parade Gardens.

In 1820, there was a disastrous fire at the Lower Rooms, with only the pillared portico surviving. This was used as the entrance to the new building for the Bath Royal Literary and Scientific Institution, finished in 1824.

That building survived until 1933, when it was demolished to make way for road works, the Institution then moving to its current location on the west side of Queen Square (see Part Four).

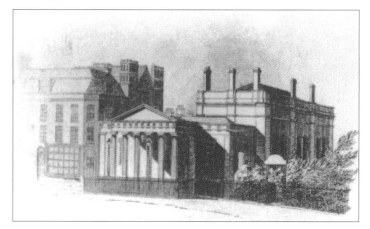

Lower Assembly Rooms

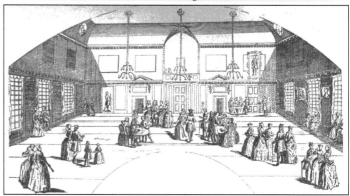

Interior of the Lower Rooms

Looking to their right as they passed the Lower Rooms, Jane and her friend would have been able to see the town house of local entrepreneur Ralph Allen in Liliput Alley.

The house is now hidden away from view by subsequent development in the more recent York Street.

From the Town House, they, like Ralph Allen, would have been able to see his "folly" known as Sham Castle on the hill to the east of the city, built in 1762 solely to provide such a prospect. You can visit this today if you wish, above North Road in Bathwick. We will pass Ralph Allen's country house later in this walk.

To the left, past the Lower Rooms, was (and is) North Parade, built in the 1740s. In Jane's time, the Parade ended at the River Avon, the bridge being built later in 1836.

People taking the air in North Parade could overlook the gardens behind the Lower Rooms by the river, with the bowling green and summerhouse.

Apart from general recreation, the gardens were used for firework displays and occasional concerts, and enthusiastic use was made on special occasions of the twenty cannon kept there. These had been bought by the Bath Master of Ceremonies, Mr Beau Nash, in 1745.

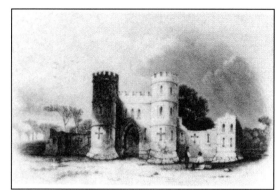

Sham Castle

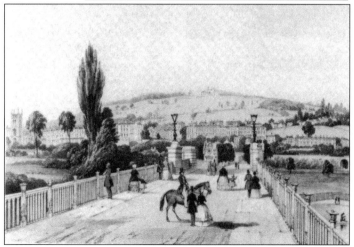

North Parade

Walking on down Pierrepont Street, Jane and Mrs Chamberlayne would have passed Orchard Street on their right, a destination with which they would have both been familiar.

In 1801, a building on the south east side of the road had been the home of the Bath Theatre Royal for some 50 years; we know that Jane attended performances there. John Palmer, before he became involved with the Royal Mail, had been successful in 1768 in getting a Royal Patent for the theatre in Bath - the first given to a theatre outside London, thus avoiding the threat of closure that hung over all unlicensed theatres.

The famous actress Sarah Siddons was a regular player at the Theatre Royal between 1778 and 1781, and she made special guest appearances thereafter. The Theatre moved to new premises in 1805, towards the end of the Austen family's stay in Bath (see Part Four), but the building still stands in Orchard Street.

At the end of the first block in Pierrepont Street, Jane and her companion would have turned left towards the river along <u>South Parade</u> – a location considered by Jane to be "too hot" for residence earlier in 1801, before the hunt for a house in Bath began.

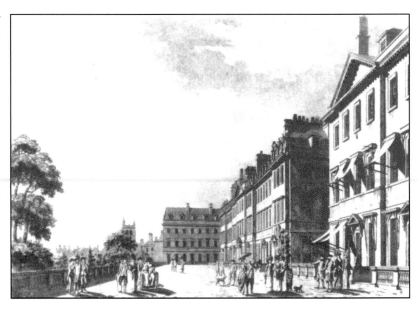

South Parade

The Whitehall Ferry had been one of the only ways across the river in the centre of the town until the Pulteney Bridge had been built some 25 years earlier. At the time of Jane's walk, the bridge was under repair, and we shall learn more about that later in the route (Part Three). Between the bridge and the ferry, a mill on either side of a weir had obstructed boats wanting to go up or downstream.

Another earlier ferry had taken passengers across the river to the north of the bridge site, using a rope to pull the boat across the river.

The Whitehall Ferry began operating in the late 1730s/ early 1740s, to service the Spring Gardens pleasure garden on the east side of the Avon. People were "punted" across the river by the ferryman – a much quicker route than using St. Laurence Bridge to the south of the city.

So we can imagine Jane and Mrs Chamberlayne taking their seats in the small boat, and holding on firmly to the side as the boatman pressed on his pole to move them across the water, until they carefully stepped out onto dry land on the other side.

Behind them lay almost all the built up area of Bath. However gracious and elegant the new streets and squares, Jane must have been looking forward with keen anticipation to reaching the open country beyond the ferry and, to the south, the destination of their walk.

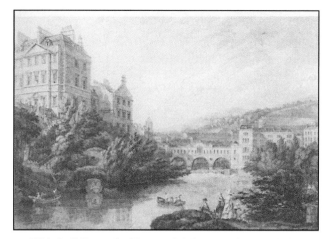

Whitehall Ferry - looking north (above) and south (below)

Part Two

From the Whitehall Ferry

(Spring Gardens)
past The Dolemeads,
Widcombe Wharf
and Widcombe,
St. Laurence Bridge
and Holloway,
St. Mary Magdalene,
Entry Hill,
Beechen Cliff,
and Lyncombe Hill

to Lyncombe Vale

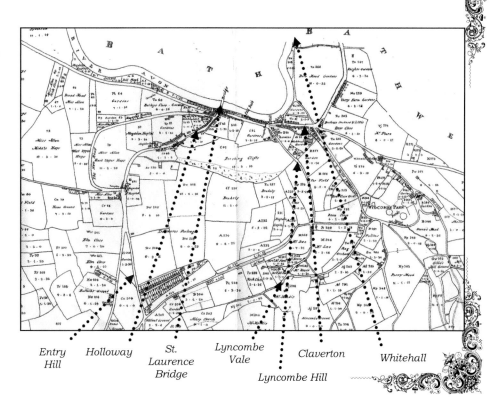

Entry Hill Holloway St. Laurence Bridge Lyncombe Vale Claverton Whitehall

Lyncombe Hill

Before turning south alongside the river, we should note that, until a very few years before Jane took her walk, there had been a very popular pleasure garden open to the public on the east bank of the river. Known as Spring Gardens, it seems have been operating as early as the 1740s, and were later advertised in (to the modern ear) extravagant terms as

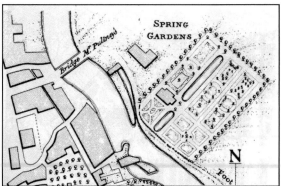

"the fair Elysum of this place, where sweet variety tempts every sense to rapture".

We can well imagine Jane Austen having no difficulty in making a pithy comment about that!

As well as walking in the gardens, visitors were able to take refreshments, attend informal dances, use the bowling green, or take a journey on a boat down the river.

An announcement in April 1766 said -

"Spring-Gardens are now open for the Summer Season with Breakfasting and Afternoon Tea, as usual. Hot Rolls and Spring Garden Cakes every morning from Half after Nine till Half after Ten, Sundays excepted. A large company is desired to give timely notice. Musick will attend if required. Constant attendance at the Passage-Boat leading from Orange-Grove to the Gardens. A Commodius Pleasure Boat to be let."

The passage boat or ferry (priced at 1d in 1767) dropped its passengers at the inclined plane still visible on the east bank of the river. To get into Spring Gardens, visitors paid a subscription of 2s 6d for a season, or 6d for each visit (in 1769) and were given a token to use within the gardens. Once the more extensive and sophisticated Sydney Gardens opened in Bathwick in 1795 (see Part Three), Spring Gardens fell out of use, and the land was later used for building houses in Johnstone Street, and for part of what is now the Bath Rugby Club ground.

A modern route across the river

Perhaps sadly, the Whitehall Ferry could not compete with the new bridges across the River Avon, and that is not an option for the walker to use now - though outings on boats are available along the river. So the easiest route across the River Avon at the present day, to follow our route to Lyncombe and Widcombe, is to use the North Parade Bridge, and then go down the stairs on the north side of the Bridge to the riverside walk. Then, turning left, the track joins the end of Spring Gardens Road and continues as a hard surfaced walkway towards Widcombe.

Jane and her companion may not have been so fortunate in 1801; in 1789, the track was one of many rural "ways" that had been in a dangerous state. However, we must hope that, in May 1801, the local path (a parish responsibility) was being well maintained.

The Dolemeads

The east side of the river had a very different character in the early 19th century from the busy city, and Jane's spirits (never good when staying with her Leigh-Perrot aunt) must have lifted at the prospect of the country before her.

At the time of Jane's walk, there were no houses on the east side of the river. However, the name Dolemedes (now Dolemeads) was mentioned in a decision made by the Prior of Bath as early as 1307 (and that name was applied to the housing built on the land following the completion of the Kennet and Avon Canal, to the east, in 1810). Then, the land was at a much lower level than now, and was regularly flooded, particularly in 1882 when the water reached the first floor of the houses; not surprisingly, the area became known as Mud Island.

The Dolemeads were also used for the dumping of household refuse, and the houses there were regarded as wretched and unsanitary. Eventually, the ground levels were raised by up to 13 feet (4 metres), and the houses were rebuilt in the early part of the 20th century.

The German bombing of Bath in April 1942 caused extensive damage to the Dolemeads, and many houses again had to be replaced. More recent works to the river have removed the threat of flooding.

Although there were no houses at the Dolemeads when she passed by in 1801, Jane and her friend would have seen the buildings near the river erected by Ralph Allen.

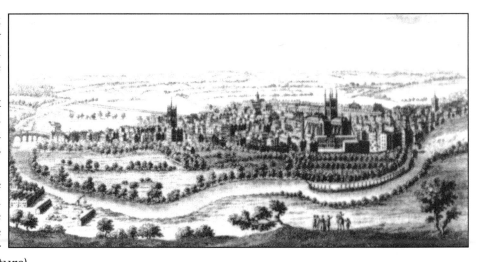

Some 80 years before Jane took her walk along the river path, he had been one of the best known businessmen in Bath; we saw his town house earlier.

He bought the stone mines on the hill to the south at Combe Down in 1726, and by 1731 was bringing the stone down by a tramway to the wharf which he built on the river bank (shown with its crane in the picture).

As we have already seen (in Part One), Ralph Allen had established the postal service in Bath, and later had been a supporter of a project to improve the River Avon between Bath and Bristol to a navigable condition. That made it possible to transport his stone, loaded by Mr. Padmore's Patent Crane at the wharf, onto barges which took the stone more cheaply than by road to Bristol and other markets – the cost fell from 10 shillings to 7 shillings and sixpence a ton.

In the 1730s, Ralph Allen built cottages near the wharf to house his workmen, and in 1736 he constructed a malthouse and brewhouse close by. After Ralph Allen died in 1764, the stone was no longer transported down the hill to the wharf, which was demolished before 1810 when the Kennet and Avon Canal was linked to the River Avon.

Some 10 years later, the Ebenezar Chapel was built close to the Canal - now the Widcombe Baptist Church that is well known for the painted text on its roof,.

As Jane and her friend continued their walk through Widcombe beyond the wharf, they would have seen the White Hart public house on the corner (still there today); it was to this point that the "Bath Guide" said that the distance for which sedan chairs could charge from the "Pump House" (Pump Room) was 972 yards. Beyond that point, the Guide accepted that the ground was *"hilly or ascending"*, including Widcombe Hill and the hill leading to *"Prior Park House and parts adjacent"*. To the right of the public house as Jane passed by were the gates closing off the bottom of Prior Park Road, then a private carriage drive to the big house built on the hill below Combe Down.

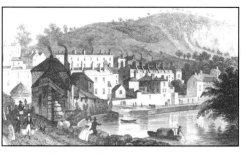

The buildings in Claverton Street, Widcombe seen from the path from the Whitehall Ferry

The two young ladies would have walked westwards along Claverton Street, past Claverton Buildings (built in 1770) and Widcombe Parade (built soon afterwards), where the small shops and public houses might well have reminded Jane Austen of the rural villages in Hampshire. In 1805, the tradesmen included a Cooper; Seedmen; Mangler; Jobbing-Smith; Tinman; Patten Maker (pattens were wooden shoes with metal framed bases); Mantua maker (a ladies cloak); and a Gingerbread maker.

Gibbs Mill was beyond the shops, close to the bottom of the road then known as Lyncombe Lane and now as Lyncombe Hill, with its mill pond extending out to narrow the roadway. Two mills at Widcombe were mentioned in the Domesday Book, so the use of water for power in the parish clearly was of longstanding. Also in that vicinity was the building known as the Cold Bath, built in 1707 (and therefore pre-dating all the

Claverton Street, Widcombe in the early part of the 20th century

bathing facilities in the centre of the city), and still in use for medical treatments at the time Jane walked by. Wood described this in these words *"The Cold Bath being the last Natural Bath of the City, the cistern is supplied by a Spring of Water which issued out of the Ground at a place where the Rays of the Sun could never reach"*. At this point, Jane and her companion would have turned to the left to walk up Lyncombe Lane (now Lyncombe Hill).

However, we shall take a short diversion by going a little further on.

Some distance ahead of us, we see the modern Churchill Bridge, completed in 1966. It replaced the Old <u>St. Laurence Bridge</u> rebuilt in 1754 (shown in the illustration with a barge from Bristol, and the wooded slopes of Beechen Cliff behind), which linked the city with Holloway and the road to Wells.

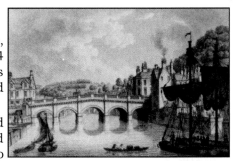

Until Pulteney Bridge had been built much further to the north, the Old St. Laurence Bridge had been the only way into the city from the south, and it would have been a shorter route for Jane and Mrs Chamberlayne to get to the bottom of Lyncombe Lane.

However, that route would have meant the two young ladies walking through the less salubrious southern part of the city. Avon Street, close to the bridge, was described in Egan's Walks through Bath in 1819 as *"the receptacle for unfortunate Women"* – not a location where well-bred ladies would wish to walk unescorted.

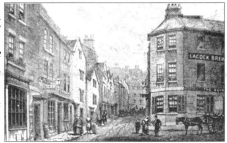

Holloway 1879

The proximity of Pulteney Bridge and the Whitehall Ferry to the fashionable part of town would therefore have made those routes a more likely choice for Jane and her friend.

<u>Holloway</u>, to the south of the bridge, was described by John Earle in his book "Bath Ancient and Modern" (1864) thus -

"In proportion as the Squares and Crescents filled with the affluent, the dens of Holloway filled with beggars.

This was their camp, from whence they watched the visitors who were their prey, and eluded the Corporation who were their natural enemies ... there they had their nocturnal entertainment, and by day they distributed themselves through the streets of Bath ... Bath, which enjoyed a pre-eminence in other things, was equally distinguished for its colony of beggars".

In the midst of the houses of Holloway (described by Warner in 1801 as *"small, mean and wretched, consisting of petty chandler's shops, dirty pot houses, slop-settlers' residences, etc."*) was a building originally used by pilgrims on their way to Glastonbury and noted by John Leland in 1542 thus ..

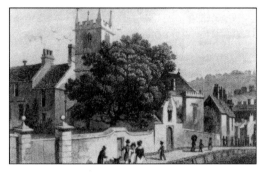

St Mary Magdalene Chapel

"I came down a rokky hill full of faire springes of water, and on this rokky hill is set a long streate, as a suburb to the cyte, and in this streate is a chapelle of St Mary Magdalene".

The church was originally built about 1100, endowed by Walter Hussey *"touched with the fear of God and for the salvation of his soul"*; it was rebuilt in 1495.

Only a little further out of the town on the route towards Wells were the attractive rural surroundings on Entry Hill (see illustration), which crosses the head of the Lyncombe Vale to which Jane is making her way.

As we return to the foot of Lyncombe Hill to resume our walk, we see with Jane the wooded slopes of Beechen Cliff, which she described so memorably in her novel "Northanger Abbey" thus -

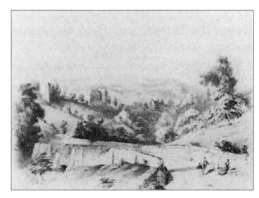

Entry Hill

... *that noble hill whose beautiful verdure and hanging coppice render it so striking an object from almost every opening in Bath. "I never look at it", said Catherine, " w i t h o u t thinking of the south of France".*

In earlier times, the springs on Beechen Cliff were an important source of water for the southern part of the city, carried through what was known as the "Magdalene Pipe" to a fresh water conduit just inside the South Gate close to St. Laurence Bridge. The Churchill footbridge carries the modern equivalent.

At the foot of Lyncombe Hill, a footway over the river known as Halfpenny Bridge would later be erected in 1863 to improve access for pedestrians to the city. However, a rush of users queuing to pay the toll before crossing to get to the annual Bath and West Agricultural Show on 6 June 1877 overloaded the structure, which collapsed onto the river, killing 8 people and injuring another 50. The bridge was replaced with the present structure within a few months of the tragedy.

Collinson wrote in 1791 in his book about Somerset,

"Widcombe and Lyncombe consists chiefly of two streets meeting at the (St. Laurence) bridge which joins the parish to the city. One of the above mentioned streets branching westward from the bridge from its deepness and concavity, Holloway, being part of the original foss road from Bath to Ilchester. The other street is Claverton Street extending south-east to the foot of the ascent to that down from which it derives its name. On the rising ground at the end of this street are some elegant detached houses beautifully situated, and commanding rich and noble prospects."

With the wooded slopes of Beechen Cliff on their right, Jane and Mrs Chamberlayne would have started the steep ascent up <u>Lyncombe Lane</u> (now Lyncombe Hill), which still taxes the energy today. There were few houses above the main street in Widcombe at this time, and the first building that they would have seen to the east (on the left hand side) was not a family house.

Lyncombe and Widcombe was one of the first parishes to provide a poorhouse (workhouse) where destitute people earned their living by being set to work if they were fit to do so. All age groups were housed together. The first poorhouse was at the foot of Lyncombe Hill, but the one that Jane would have seen was built to house 100 people on two acres of orchards purchased from the executors of Ralph Allen, with the higher part of the land set aside as a burial ground. The burial ground remains, but the poorhouse was demolished in 1961 and replaced by housing for elderly people.

Most of the houses that now line the hill were built after Jane's walk - the two that the ladies would have seen in 1801 were Southcot House, built in 1757 on the left hand (east) side, and Pope's Villa (now Calton Grange) on the right. As the young ladies admired the rural scenery, they might well have agreed with J.Tunstall in his book "Rambles about Bath" (1851) that

> *"The Vale of Lyncombe has not changed; it is still beautiful, and Lyncombe Hill, another delightful walk by which it may be approached, presents, at every opening, unsurpassed views, .."*

Once past the crossroads at the top of the hill, Jane and her friend walked on, nearing their first destination of Lyncombe Vale. In 1791, the Reverend J. Collinson wrote in his book "The history and antiquities of the county of Somerset" -

> *"that part of the parish (of Widcombe) that still retains the name of Lyncombe is nearly half a mile to the south (of Claverton Street in Widcombe), and is situated in a deep, winding and romantick valley, watered by a small stream, and interspersed with gardens, meads and woods .. Towards the east stands a group of five neat houses (four of them newly erected) on an eminence, denominated from its eminence, Hanging Lands, and commanding a fine prospect of Bath and the circumjacent country."*

Along the valley runs the Lyn Brook, with wooded slopes on the southern side; opposite to the north, the land is more open and is now developed with modern houses. The valley is known to some local people as "Watery Bottom".

On the left, after the first bend in the road, was (and is) Lyncombe Hall, one of four large houses that had been built at the time of Jane's walk. On their right as they went down the slope of the road into the bottom of the valley, they would have seen some "touchstones" which are still there today: these were to prevent the wheels of a carriage catching on the walls as the vehicle went down the hill.

Hidden away above the right hand (west) side of the road on the middle slope of the valley lies the site now known as Lyncombe Court, where the grounds were used as a successful "pleasure garden" for about 15 years from 1778 onwards, with fossil shells (a personal interest of the proprietor Charles Waters) incorporated in the boundary walls.

Fossils were sold by the stone quarrymen at Combe Down, and some of them may have come from there.

The greenhouses and hot houses were a special feature, with plants being made available for sale. Refreshments were offered, and the peaceful location, plus the entertainments including fireworks, musicians and gambling, made the attraction popular until the competing entertainments nearer to the city proved to be too strong competition. In more recent times, Roman wells were found within the grounds.

From the Bath Chronicle for 14 August 1766 -

"There will be a Carnation Feast at Richard Lancashire's at Lyncombe.

He that shews the three best whole blown carnations of different Sorts will be entitled to a silver Punch-Ladle; he that shews the best whole blown Burster ditto to have a Gold Ring; and he that shows the best whole blown ditto, to have his Ordinary (set meal) and Extra-Ordinary (extra dish) free. To be adjudged by Proper Persons chosen out of the said company. No person to shew for the prizes unless he dines with the Company."

A characteristic of the hills around Bath are the two layers of the oolitic limestone separated by a mixture of fullers' earth clay and rocks. The top layer of stone is often suitable for building.

The ground water flows upwards to the surface, and often emerges as springs where the fault encounters the clay. Springs like these are a feature of Lyncombe Vale.

In July 1786, Elizabeth Sheridan went with others to King James' Palace.

"When we arrived, a little girl informed us thro' the (upper) gate that we could not be admitted as it was Witcombe (sic) revel - on those occasions they shut up all public places here so fearful are they of anything that might promote mirth.

She would let us in but no tea was to be had ... and we stroll'd round the gardens which are really very pretty."

Down the slope on the left was the house known in the 18th century as Lyncombe Spaw (right), where the discovery of springs with supposedly curative qualities close to an existing fishpond had led to the building being used for about 30 years as a residential centre for people seeking to improve their health.

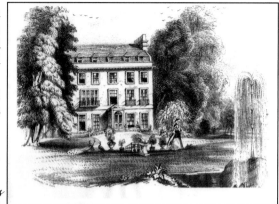

By the time of Jane's walk, the house had returned to normal family use and was known as Lyncombe House. The house and its attractive grounds are now used as a private school.

The Reverend John Penrose wrote to his family from Bath in 1766 to describe his visit to Lyncombe Vale -

"Another head of discourse, our walk to Lyncombe. Our way to it was over the Grand Parade, and through Duke Street, and part of the South Parade, across the Ferry, then down to the Crane for loading barges with free-stone.

So far level Ground, and pleasant walking; but from thence to Lyncombe, the longer half way, or rather two thirds almost of the Way, an uphill and downhill, very rugged and uneven. However we got to Lyncombe in good Season. I was much tired, sweating as if in a Bagnio; was glad of a glass of wine, yet recovered myself so well before dinner came in, that I made a most excellent meal. The Colonel's Lodgings, on the side we entered the house, is two pair of stairs up; on the opposite side, but one pair, that side being under ground. It is a very pleasant situation, in the midst of a variety of rural scenes, not that less pleasing for being rural. "

From the Bath Journal for 20th May 1751 –

"This is to give notice that Messrs Charles, the French-Horn Masters, with a bank of Musick are to perform a Concert at Breakfast upon a variety of instruments at Lyncombe Spaw House, near Bath on Tuesday, the 21st instant; and all those who are pleased to honour the house with their company, will meet with no other expense than what they please to spend, it being entirely for the benefit of John Weber, who keeps the said house. To begin at 10 o'clock. If the weather does not prove fair, it will be put off until next Thursday morning - if the ladies should be desirous, after the concert of country dances, proper Hands will be ready to attend".

Some 60 years after the date of Jane's walk, there was a novel intrusion through Lyncombe Vale.

The Somerset and Dorset railway line from the station on the west side of the city centre needed to pass through the grounds of Lyncombe House (the former Lyncombe Spaw), then owned by a local solicitor. He drove a hard bargain, concerned about the effect of forming a cutting and the beginning of a long tunnel through his grounds. After negotiations lasting 5 years, he retained the land ownership, was paid £1900 compensation, and had the railway company build footbridges and carry out extensive landscaping works, as well as guaranteeing to remedy any damage to the water supply caused by interruption of the springs on the land.

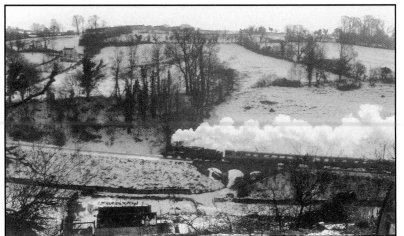

The Somerset and Dorset Railway line through Lyncombe Vale

An eyewitness account at the time the route was completed described the Lyncombe Vale section thus –

"*... we found ourselves crossing the romantic Lyncombe-vale, on one side of which are green fields, and on the other neatly cultivated and fruitful market gardens. Immediately after we are in a rugged oolite cutting, which runs through the fields of Mr. Moger, for whose convenience a fly arch bridge, over which the footpath to Fox-hill passes, has been erected. ... This arch, by the aid of turf, plants, and other garden accessories, has been made as pleasing an object from the house as a railway bridge, perhaps, could possibly be under the circumstances. Directly we have crossed the viaduct, we shoot into the north end of the Combe Down tunnel, and the transition from the pleasing rural scenery to the cool gloom of the tunnel is a novelty*". He could have added that the journey was also very smoky. At a mile and a quarter in length, it was the longest unventilated tunnel in the country, and the steep incline required the use of two engines. The railway line was closed in the 1960s, and the track removed.

Before leaving this part of the vale, we should note that use of the land in the valley has a long history.

Owned in mediaeval times by the Prior of Bath, names such as Vineyards and Fishponds on local maps indicate that the Prior used this sunny valley with its steep sides for supplying his household.

In 1322, the then Bishop of Bath and Wells decreed that the Vicar of Widcombe and his successors should have the tithe (a tax of a tenth) of all the wool, hay, milk, geese, pigs, pigeons, eggs, flax, leeks, apples, calves and ale in the parish of Widcombe and Lyncombe. It seems very likely that some of these would have come from Lyncombe Vale. The

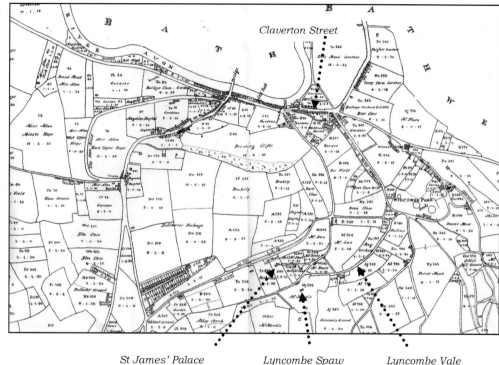

St James' Palace Lyncombe Spaw Lyncombe Vale

north-western side of the valley was used for market gardening until the last century, supplying the city with fresh vegetables and fruits. It is perhaps not too fanciful to imagine that, with a Roman villa not far away on the hill, and Roman remains found in the area to the east, the founders of the Spa more than 1500 years ago may also have used Lyncombe Vale to supply their needs.

Jane Austen and Mrs. Chamberlayne would now have turned eastwards, along the road is now called Lyncombe Vale.

First, they would have walked down the slope between the stone walls of Lyncombe Hall and Lyncombe House, until the valley opened out again in front of them.

The terraced and other houses on the left hand side of the street were not built in her day, but Jane would have passed Lyncombe Farm on her right, as the Lyn Brook emerged from the grounds of Lyncombe House.

The reader will remember the description in her letter to her sister, Cassandra Austen –

".. and for many, many yards together on a raised narrow footpath I led the way ..."

Here ahead lies the most likely location for that comment, since the stream is bounded on the road side by the footpath rising at an increasing height above the highway. In 1801, with no houses apart from the farm in this part of the valley, there was only a rough track beside the stream, and the reader may wonder why the water is kept in place by this unusual feature.

The most likely explanation, although not the only possibility, was that it had been moved at an earlier date from its original course at a lower level on the northern side of the valley in order to make a maximum fall of water when it reaches the site of a mill some hundred yards further on, to drive the mill wheel.

Whatever the explanation, we can follow in Jane's footsteps along the raised footpath, bending our heads under the trees that overhang the path, and enjoying the contrast between the fields on our right, and the beginning of the urban area on our left.

At the end of the road, and before we reach the site of the mill, we come across the location of another pleasure garden in Lyncombe.

Known as "The Bagatelle", it operated at the corner of the new roadway built by Ralph Allen to carry his stone down to the wharf at Widcombe. The story began when a Mr. Wicksteed purchased the land in about 1737, no doubt hoping to get business from people passing the site to see Ralph Allen's house at Prior Park and his stone "railway". Mr. Wicksteed engraved seals, which visitors bought as souvenirs at his shop in Orange Grove in the city centre (see Part One). His new engraving mill in Lyncombe Vale was powered by water. The business continued under his son until the early 1760s, when more orchard land was purchased in the valley.

In 1769, the finding of a beneficial spring on the land was announced, and by 1770 refreshments were being offered to visitors at "The Bagatelle".

The now familiar additions of music and public breakfasts and private dinners were offered, and visitors were also able to see the seals being engraved and view an illuminated fountain. However, although a second house was built, it appears that a family dispute led to the site being sold during the 1770s.

The new owner added a 60 foot long "canal" for men's cold bathing along the orchard land – perhaps utilising the natural propensity of the stream to flood in wet weather.

The site changed hands again and by 1786 was overgrown with weeds. The two houses on the land remain at the present day.

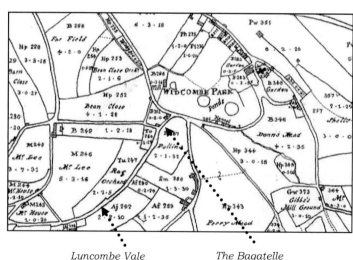

Lyncombe Vale The Bagatelle

Part Three

From Lyncombe Vale

past Prior Park, Widcombe Manor,
St Thomas à Becket Church,
Widcombe Hill,
the Kennet and Avon Canal,
the Bristol to London railway,
Sydney Gardens,
Sydney Place and
Great Pulteney Street,

to Pulteney Bridge

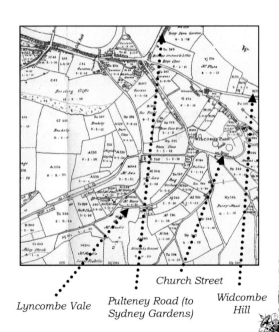

Lyncombe Vale Pulteney Road (to Widcombe
 Sydney Gardens) Hill

 Church Street

Although Jane and her friend would not have seen stone being transported down the hill from Combe Down as they crossed the Carriage Drive from Lyncombe Vale towards Church Street, the image (right) would have been available from shops in the town. The regular slope of the Drive would have enabled them to imagine the route busy with loaded wagons, controlled by the brakemen as the wagons ran down the hill on cast iron wheels running on oak rails. Each laden wagon carried between 3 and 4 tons of stone, the empty ones being pulled up the long slope of the hill by horses. The Tramway became one of the sites of Bath for visitors to inspect in the mid-18th century, as the picture shows.

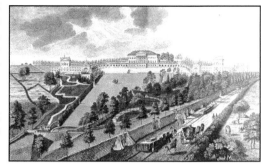

Prior Park from the north

As a home for himself and a dramatic advertisement of the qualities of his stone, in 1734 Ralph Allen began the construction of a handsome mansion on the hill east of the Tramway, which had magnificent views down the valley below to the centre of Bath. He moved into his new home around 1741, and the house known as <u>Prior Park</u> became a focus for entertaining writers such as Henry Fielding, Alexander Pope and Samuel Richardson, as well as the artist Gainsborough, actors like David Garrick, and other major persons of the day. The gardens were landscaped, and the Palladian Bridge was erected further down the slope in the 1750s.

After completion, the house was described as *"A noble seat, which sees all Bath, and which was built for all the world to see"*. When Ralph Allen died in 1764, he owned large areas of land in Claverton, Bathampton, Odd Down and Widcombe, as well as Prior Park and Combe Down. The building was badly burnt in a fire in 1836 after it had become a school and another, less severe, in 1991. The gardens have now been restored by the National Trust and are open to visitors.

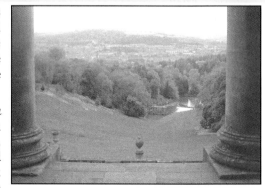

View from the terrace of Prior Park

Ralph Allen's house Prior Park, seen (in the picture on the right) on the hill above Church Street, had been built on land in the Manor of Lyncombe originally controlled by the church.

There was said to be a water mill in the 11th and 12th centuries at the junction of the Lyn and Widcombe streams close to Church Street, and the site may be even older, as remains apparently of Roman origin were seen during a flood in 1963. The building on the site is now a car dealer/service garage. The access to the mill from the city would have been close to the line of the later Carriage Drive. The old route is shown on maps to have continued up the hill via the end of Lyncombe Vale to Perrymead (or Pope's Walk - see photograph) and then to the top of Combe Down. Although this track would have been suitable for pack animals, clearly a wider and better graded road had been needed to transport quantities of stone in the 18th century.

The Priors who ran the Benedictine Priory in Bath are thought to have had a country house towards the bottom of the grounds of Prior Park, close to Church Street and the mule track to the west of the Church, up to what is now known as Rainbow Wood.

Documents indicate that some of the land was used for fishponds, barns, an ox-house and vineyards, as well as running deer, until the Dissolution of the Monasteries by King Henry VIII.

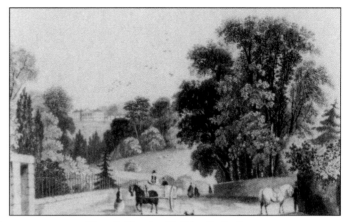

Church Street with Prior Park above

Pope's Walk towards Combe Down

Jane and her companion would next have come to the house now known as <u>Widcombe Manor</u> which, with the St Thomas à Becket Church, forms one of the most attractive scenes in a semi-rural setting close to the city.

There had been an earlier house on the site before the present structure, which is thought to have been built in the middle of the 17th century. It was subsequently altered by Philip Bennet, who married the daughter of Scarborough Chapman, a member of a well-known Bath family, in 1727. Both his wives died in their twenties, (probably in childbirth), but it may have been during the second marriage, in 1736, that the house was remodelled.

The name of the architect is not known, but his creation, although subsequently altered in some details, has delighted the onlooker for nearly 300 years. The decoration on the house includes stone garlands, cornucopae and "green men" over the windows. The fountain in the courtyard, though old, is a more recent addition.

Philip Bennet, after rebuilding the Manor, persuaded Ralph Allen to agree that the road (now known as Church Street) could be extended to Allen's Carriage Drive to get better access to Bennet's handsome "new" house – at that time, most of the development further east had not been constructed. As can be seen by comparing the print and the photograph taken two centuries later, the house still enjoys a leafy setting to please the passers-by as they walk along Church Street.

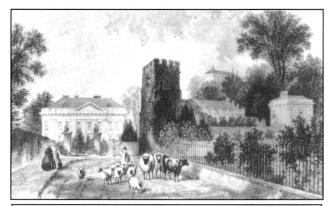

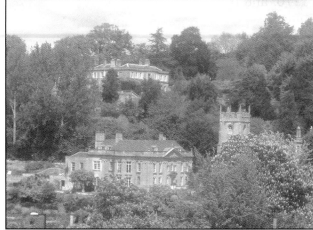

Widcombe Manor with the church, and Crowe Hall above

Jane and Mrs. Chamberlayne would have continued by walking past one of the most delightful churches in Bath which, with the Manor, forms a very attractive scene. The view has change little over the years.

Jane Austen might well have felt at home in St. Thomas à Becket Church, as the rural situation and the scale of the building may have reminded her of country churches in her home county of Hampshire.

There is a pre-983 psalter (gospel book - right), believed to have come from an earlier church on this site at Widcombe, and now in Corpus Christi College at Cambridge, which includes text referring to a transaction between the Abbot of Bath and a resident of Lyncombe.

Archbishop Thomas à Becket was murdered at Canterbury in December 1170, and the second church on the site at Widcombe was built at about that time.

The present church was begun in about 1500 by the then Prior of Bath Abbey, John Cantlow, at the same time as the Abbey itself was being rebuilt; they are said to be the only two churches remaining in Bath that were built before the 17th century.

There are fine stained glass windows in the Widcombe church, unusually showing not people but shrubs, plants and flowers represented in the Bible.

Continuing along Church Street, Jane Austen would have seen a much more rural view than now, as Widcombe Crescent (at the end of the road on the left) and the majority of the other houses that we pass were built after 1801.

At the end of the street, there is the route to the right, up Widcombe Hill to Claverton Down, again undeveloped at the date of Jane Austen's walk. The Down was the venue in the 18th century for the Bath Races, attended in the most successful year (1777) by 800 carriages and 10,000 horse-riders and people on foot.

Tyte in his "History of Lyncombe and Widcombe" (1898) recalls the first policeman to appear in Widcombe in the 19th century. His watchbox was on Widcombe Hill, at the end of Tyning Lane opposite Church Street. A very tall man, the regulation uniform did not fit him well, as the blue coat with swallow tails was too small, and the white trousers too short. Hopefully, his chimney-pot hat was a better fit.

The postman, by contrast, was only 5'2" tall, and wore a light brown long frock coat, trousers of the same colour, and buckle shoes.

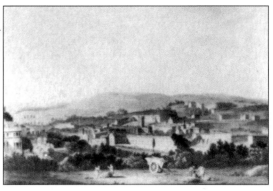

View from Widcombe Hill

The Natural Theatre Company "clock heads"

On the Hill now as we walk down towards the river again is a former school on the left, now used as the base for the "Natural Theatre Company" – an innovative theatrical group that is popular all over the world.

For the Queen's golden Jubilee in 2002, the residents of Widcombe celebrated by producing a Millennium Map (right) recording the history of the area.

Going down Widcombe Hill, Jane and her friend would have reached the corner by the Carriage Drive, with the White Hart nearer them, and the end of Claverton Street beyond. The two ladies would then have turned to their right, and seen ahead of them the Widcombe turnpike gates, a sign that the road ahead towards Sydney Gardens would be better maintained than some of those they had been using on the walk.

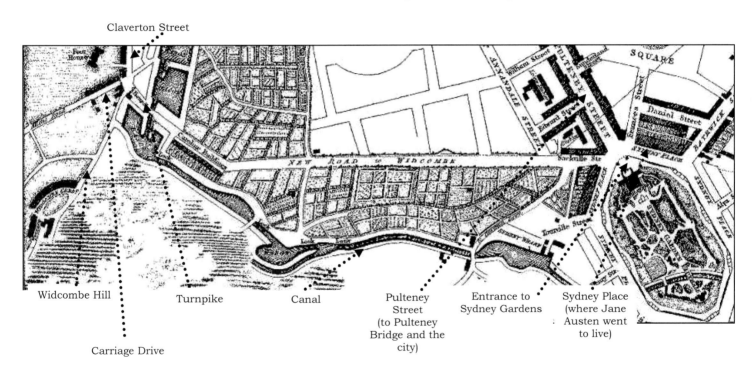

Claverton Street

Widcombe Hill

Turnpike

Canal

Pulteney
Street
(to Pulteney
Bridge and the
city)

Entrance to
Sydney Gardens

Sydney Place
(where Jane
Austen went
to live)

Carriage Drive

In 1801, the connection of the <u>Kennet and Avon Canal</u> with the River Avon in Widcombe had not yet been made, delayed by technical and legal difficulties.

By the date of Jane's walk, the Canal had reached Sydney Wharf to the east. The remaining locks and turning basin would be completed by 1810, which would require the turnpike gates to be moved about 30 yards further to the west. The Canal (which links Reading and Bath) had about 30 years of profitable life carrying goods, before it was superseded by another method of transport that would also revolutionise travel for the majority of people, and spell the end of the stage-coach era. In the 20th century, the Canal was restored and is used for leisure boating.

The Kennet and Avon Canal was linked to another water-borne route – the Somerset Coal Canal. The route for that canal had been surveyed by a remarkable man – William Smith.

As a result of his investigations into ground conditions for the route, he began to develop his data which led to the publication of the first map of geological strata in 1815. William Smith lived for a time in a cottage at Tucking Mill, at the further end of the Somerset and Dorset rail tunnel, and elsewhere in Bath. He certainly visited the Bath area whilst Jane was living in the city.

We know from another of her letters that she planned to visit an innovative means of lifting boats up to a higher level on the Somerset Coal Canal in the Bath area – the cassoon at Combe Hay. As her uncle, who Jane liked much better than his wife, was not an energetic man, it seems most likely that, if they did see the cassoon, the journey would have been made by coach.

Widcombe Turnpike

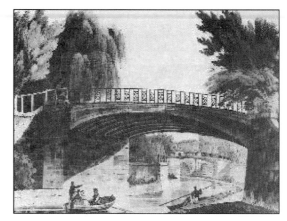
The Canal at Widcombe

It seems likely that Jane would also have been intrigued by the advent of the railways into the West Country. Isambard Kingdom Brunel proposed a "Great Western Railway" (GWR) between London and Bristol, and the line from Bristol reached Bath in 1840.

Hundreds of people filled the meadow on Lyncombe Hill below Beechen Cliff to cheer when the first locomotive came into Bath Station. In 1841, the entire route to London was opened.

The arches under the railway line were left open, so that residents in the parishes to the south could still reach the city centre on foot and by horse-drawn vehicle.

A particular requirement imposed on the GWR was not to *"drain, divert or otherwise intermeddle with any springs, streams, watercourses, mains, pipes, reservoirs or cisterns of water in the Parishes of Lyncombe, Widcombe or Bathwick"*. Clearly the Bath Council was guarding its water supplies carefully.

Caroline Buildings, on the right beyond the bridge over the canal, were built in 1804. So we can imagine a more rural scene than now, as Jane Austen and Mrs. Chamberlayne walked along the road in 1801 towards the more developed area at the eastern end.

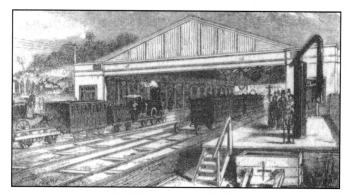

Bath Spa Railway Station

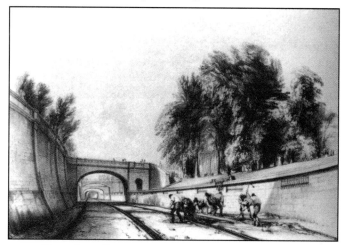

The railway line to London under construction in Bath

41

The plan of the city of Bath shows the openness of the land between Widcombe and Bathwick along the turnpike road. So reaching the end of Great Pulteney Street on the left, and Sydney Gardens on the right, would have been much more of a contrast for Jane and her companion than it is for us today.

As already mentioned, several "Gardens" and other attractions had opened (and closed) during the 18th century. Sydney Gardens was the one of the latest, and proved to be the most successful. Laid out as part of the Bathwick Estate developed to the east of the River Avon in the second half of the century, the Gardens opened in 1795.

Linked by the new Pulteney Bridge to the city centre, the Gardens were an instant success. Some 4000 people attended the first Gala held in 1796, and the visit of the Prince of Wales to Sydney Gardens later that summer was a further endorsement. Jane, on one of her earlier visits to Bath, wrote that the King's Birthday Gala, held for a second time on 18 June 1799, had very pretty illuminations, but the fireworks surpassed all her expectations.

A Tavern (later a hotel) facing towards Great Pulteney Street was opened in 1799, with special rooms for refreshments such as daily public breakfasts, reading newspapers and playing cards. The ballroom seems to have been on the first floor, and rooms could be hired for special celebrations. Concerts and other entertainments were held both inside and out.

Sydney Gardens (above)
and the Hotel (below)

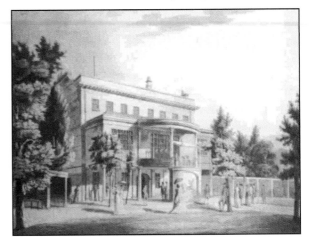

42

We know from one of her letters than Jane did not enjoy concerts at the Gardens –

"... *even the concert will have more than its usual charm for me, as the gardens are large enough for me to get pretty well beyond the reach of the sound.*" But she records on another occasion entering soon after 1, and not returning until 4, so we may safely assume that she enjoyed the Gardens in other respects.

Not long after the Gardens opened, the route of the proposed Kennet and Avon Canal was decided, following a design by the engineer John Rennie, and the work through the Gardens had been carried out by May 1801. The Canal was constructed in a 12 foot (3.6 metre) deep cutting, to a curved alignment which gave it a pleasantly informal appearance.

Two decorative cast iron bridges were brought to the site in sections and then bolted together. These and other carefully chosen details resulted in the Canal becoming an attractive addition to Sydney Gardens. Fly boats used the Canal from Sydney Wharf to Bradford on Avon, with the two hour trip offering first and second class cabins, liveried servants, and entertainment by a small orchestra – a more modern equivalent journey is available today. In the mid-19th century, a chain across the Canal prevented such frivolous journeys on a Sunday.

The plan of the Gardens shows serpentine walks through the area of 16 acres, with arbours of climbing plants, the bowling greens, the labyrinth, and the swings. There was also a grotto, waterfalls and pavilions. Visitors could stroll about, ride on horseback around the perimeter, or take tea.

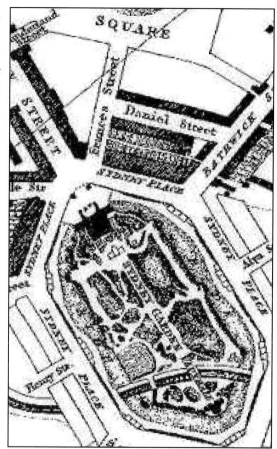

A twelvemonth after Jane's walk, Sydney Gardens was the site of an exciting novelty, and tickets were sold at high prices to witness the spectacle from within the Gardens. An experienced French balloonist, Garnerin, made an ascent from the Gardens in September 1802, and a safe landing some miles to the south-west at Mells, near Frome.

As Jane and her family were by that time living in Sydney Place, directly opposite Sydney Gardens, perhaps they saw the ascent from their front windows, as the balloon rose above the trees and was blown southwards. It would have pleased Jane, who was always (of necessity) prudent with money, to have saved the cost of a ticket.

Further innovations added to the Gardens in the 19th century, after Jane left Bath, were the Theatre, Watermill, Cosmorama, Aviary and the Cottage. Concerts continued to be held there, and later annual flower and plant shows were popular.

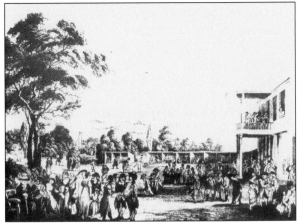

Sydney Gardens and the Hotel

In the 1860s, remains of a Roman cemetery were found in Sydney Gardens; the cemetery must have extended across to Sydney Place, as an ancient altar had been found on the site there when the houses were being built in 1793.

The advent of the London to Bristol Railway in the 1840s was a less welcome intrusion into Sydney Gardens, as the cutting was much nearer to the Hotel than the Canal had been, and the perimeter walk and ride around the Gardens had to be severed. Use of the gardens declined, and later in 1916 the Hotel became the Holburne Museum, still open today and showing art and artefacts. The Sydney Gardens are also open to the public, although most of the features, and certainly the more novel ones, have disappeared.

To return to Jane's walk, at the entrance to Sydney Gardens, Jane and Mrs. Chamberlayne would have seen Sydney Place ahead of them as they turned to their left, to walk along Great Pulteney Street and go back to the city centre.

Their father also shared this preference, but Laura Place and the rest of the area east of the river on the Bathwick Estate was thought to be too expensive for their limited income. In their search in May 1801, Jane and her mother were looking at houses to the west of the city centre (and not too near her aunt Leigh-Perrot at The Paragon on the north side), in Seymour Street, New King Street, and in Green Park Buildings.

Jane wrote to Cassandra -

"It would be very pleasant to be near Sydney Gardens! We might go into the labyrinth every day."

The family of four did not need to rent a very large house, as they planned only to employ a manservant, cook and housemaid. By whatever means, the Austen family eventually

Sydney Place (left)

heard of a house available to rent in <u>Sydney Place</u>, which was one of the few streets in the Bathwick Estate to be built around the same time as the gardens, and which faces west over them. The advertisement in the Bath Chronicle on 21 May 1801 said

"The lease of No.4 Sydney Place, 3 years and a quarter of which was unexpired at midsummer. The situation is desirable, the Rent very low, and the landlord is bound by contract to paint the first two floors this summer. A premium will therefore be expected."

Beyond Sydney Place and Sydney Gardens lay open countryside, with opportunities for walking and exercise. To the west towards the city, the land was also open, as Daniel Street had not been built at that time. It would not be surprising if the open outlook on both sides was a factor that the family (and in particular Jane and her sister) considered important in deciding to rent the house.

No.4 Sydney Place was redecorated during the summer, whilst the family was on holiday in Devonshire; by the end of October 1801, they were back in Bath, overseeing the last of the works needed to the house. Until the autumn of 1804, No.4 was to be their home.

In 1743, Bathwick was an area of market gardens and pleasure plots reached by the Bathwick Ferry, or by the long walk south through the city to the St. Laurence Bridge, and then east through Widcombe.

When William Johnstone Pulteney inherited land to the east of the River Avon, he spent many years purchasing more to create the Bathwick Estate. Terms were agreed with the Bath City Council to obtain land on the city side so that a new bridge could be built to give access to the future development. In return, the estate gave land for a new gaol on their side of the river, in Grove Street to the north-east of Pulteney Bridge, and the gaol was built between 1772 and 1773.

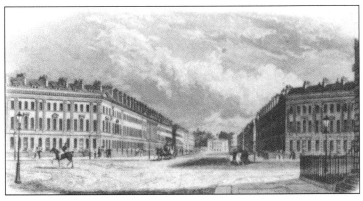

Great Pulteney Street from Laura Place

Legal and other delays meant that Laura Johnstone Pulteney, who inherited the estate in 1782, could not develop the Bathwick Estate land until 1788. Sydney Gardens had been intended to be the focal point of the estate, with 8 residential terraces around it, more on the land nearer to the city, and up Bathwick Hill. The failure of the Bath Bank in 1793 made the architect, Baldwin, bankrupt, and the only terrace completed initially around the Gardens was Sydney Place, where Jane Austen lived.

Great Pulteney Street was the link between the Sydney Gardens and the city via Laura Place (above) and the new bridge. The street is 100 feet (30 metres) wide and 1100 feet (335 metres) long. Originally it was lined with trees on both sides, but these were later removed to improve the distant views. At Laura Place, Johnstone Street goes south, built partly on the site of Spring Gardens. To the north, Henrietta Street eventually led to Henrietta Park. The park was laid out on low lying land originally intended for housing until the failure of the Bath Bank, and was first named Bathwick Park. The 7 acres of land were later given to the city by the then owner of the Bathwick Estate, Captain Forester, whose name is commemorated nearby. The park was opened in 1897, the year of Queen Victoria's Jubilee. In Henrietta Street was one of the many private 18th century chapels built in Bath – Laura Chapel – where it is believed that Jane Austen and her family worshipped.

Pulteney Bridge was designed by the architect Robert Adam and was built between 1769 and 1775.

The narrow bridge was based on a Palladio design for the Rialto bridge in Venice. It was unique in having shops on each side, which you can still see if you go there today.

The bridge was an important feature in the plans by the Pulteney Family to develop their land on the east of the river, as it linked the new residential areas on the Bathwick Estate with the old centre of the city.

At an early stage after the completion of the bridge, there were signs of subsidence, as the left hand pier began to sink, and thought was given to completely pulling the bridge down. However, by 1801, it was decided that the best course was to rebuild the western end.

During the rebuilding period, a temporary wooden structure was erected to maintain access to the Bathwick Estate. That was the situation when Jane and Mrs. Chamberlayne took their walk, so it is likely that they would have used the temporary wooden bridge to return to the city centre. From the west side of the bridge, Jane and her companion could have made a short return to The Paragon via Broad Street.

However, with Jane's prodigious energy - it was not rare for her to take two walks in a day - we will follow her to places on the west side of the city centre not yet mentioned, and to which we know (from her letters) that she went on other occasions during her time in Bath.

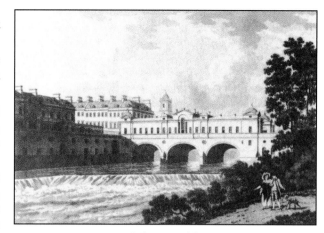

Pulteney Bridge

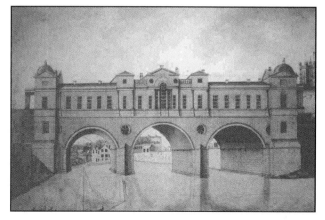

Part Four

From Pulteney Bridge

across Milsom Street,
to the Theatre Royal,
Queen Square,
Royal Crescent,
Crescent Fields (Royal
Victoria Park),
and back
via The Circus, and the
Upper Rooms (the Assembly
Rooms)

to No.1 The Paragon

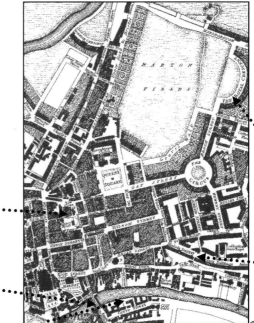

Royal
Crescent

Theatre
Royal

No.1
The
Paragon

Pulteney
Bridge

After returning across Pulteney Bridge, we shall look at the other more urban attractions in Bath, some of which Jane Austen disdained, but nevertheless made use of during her time in the city. To reach these, we will walk across the city towards the west

To reach these locations, Jane and her companion would have retraced their steps, either as far as St Michael's Church, and then west along Green Street or (since New Bond Street did not exist in 1801) by turning earlier, across from Bridge Street along Upper Borough Walls.

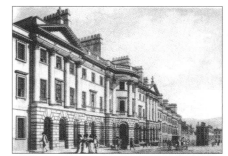

In both cases, they would have found themselves at the next junction of streets in <u>Milsom Street</u>. The road had originally been designed for residential use but, perhaps due to its location, rapidly became a sought-after shopping area. In this respect, with its shops and banks, Milsom Street is little altered in its function today.

To visitors to the Georgian city, the shops offered a range of very fashionable merchandise of every kind that was one of the attractions of Bath. We know that Jane Austen was interested in shopping, both for fashion and for food. Markets such as those around the Guildhall were the important source of food. Jane also refers in her novels to characters using pastry cooks in Milsom Street.

Milsom Street - northern end (above) and southern end (below)

For fashions, however, other locations, and in particular Milsom Street, were where the ladies of quality would find the best shops, and go to choose their garments, trimmings and accessories. She was typical of visitors to the city in that not only did she shop for her own needs and those of her family with her, but she also carried out "commissions" from friends and relatives unable to visit the city themselves.

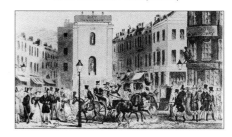

So both the young ladies would have been on familiar ground as they crossed Milsom Street from east to west, and walked through Quiet Street.

The visitor strolling around Bath today may perhaps come across an artist drawing the scene on an easel, sketching a likeness of a passer-by, or using a paving stone for a chalk replica of a well-known painting. In Jane's time, well-known artists had elegant showrooms in their rented lodgings, which a servant would show to any persons of quality who might call.

Perhaps Jane might have looked in one of those showrooms, as she did later in 1813 at public exhibitions in London, for a likeness of Mrs. Darcy (Elizabeth Bennet in "Pride and Prejudice") in a yellow dress, but without success.

From Milsom Street, Jane could have walked along Quiet Street, as we can, towards Queen Square. Turning left there brings the walker to the <u>Theatre Royal</u>.

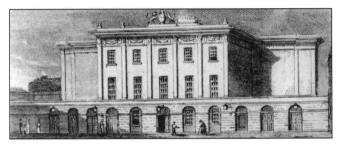

The Theatre Royal

exterior (left)

and

interior (right)

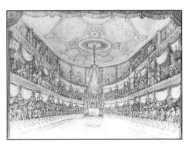

Jane and her family had been keen on amateur theatricals in Hampshire, so we may be sure that she would have taken a keen interest in the professional theatre in Bath.

As Bath expanded, the old Theatre in Orchard Street became too small and, at about the time that Jane took her walk, consideration was being given to replacing it. In 1804, it was decided to build a new Theatre on the north-west side of the old city. The Theatre was constructed in just over a year, with its entrance on the north side in Beauford Square; it had three entrances for the increased number of patrons, and tiers of private boxes, as well as a pit and gallery. In her book "Mansfield Park", Jane refers to Charles Musgrove taking a box in the new theatre. It was long after Jane Austen's time, in 1862, after a fire, that the entrance was moved to the east façade as we see today.

From the Theatre, the two young ladies would have retraced their steps to the south-east corner of <u>Queen Square</u>. The Square had been erected between 1729 and 1736, and is one of the first classical architectural "set pieces" in Bath, named after Queen Caroline, wife of King George II.

Designed by John Wood, and a very fashionable residential location in its early years, Jane had stayed there in No.13 with her family in 1799. To begin with, there were no trees in the centre of the Square, and Jane would have seen gravelled and grass walks, surrounded by "pallisades".

The west side was in two terraces at that time, with a house set back between them. The central three houses were not erected until the 1830s - they later became the home of the Bath Royal Literary and Scientific Institution, which still is active there today.

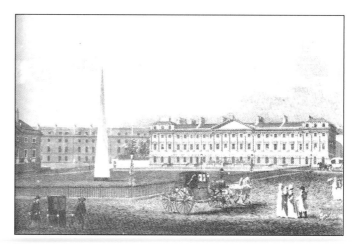

The Square houses an Obelisk in the centre, erected by Beau Nash (the Master of Ceremonies who organised social occasions in the city) in 1738 in honour of a visit by the Prince and Princess of Wales. Railings now surround the Square, with the gravelled areas within used for the annual "Boules Tournament" in July. The Square is a popular place for picnic lunches on sunny days.

As we have seen elsewhere in Bath, the Romans got there first, with Roman cremations having been discovered at the north-west corner of the Square.

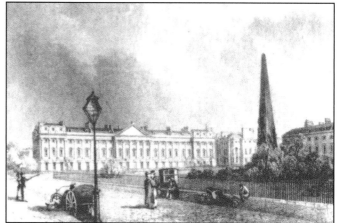

From the north-west corner of Queen Square, a carriage drive leads towards the <u>Royal Crescent</u>. The two little "houses" at the entrance to the drive are thought to be rests for the sedan chairmen, or perhaps somewhere for them to shelter from the rain whilst waiting for their next fare.

Walking along the drive, Jane and her companion would soon have caught a glimpse of the Royal Crescent. One of the many glories of Bath, and perhaps the greatest, Royal Crescent contains 30 large houses in a gentle curve over 600 feet long, fronted by a cobbled roadway. Completed in 1775, it was intended to house the wealthiest visitors to the city, and rapidly superseded Queen Square as the most fashionable residential location – a reputation it retains today.

The Crescent would have been well beyond the resources of Jane's family as a place to live – its tenants in the 18th century included the Duke of York, son of King George III. Another resident was the author Christopher Anstey. He lived at No.5, having written his "New Bath Guide" in 1766, which ran through 30 editions in the next 50 years and made him a wealthy man.

No.1 Royal Crescent is now a museum, displaying period furniture to show how a grand house would have looked to Jane and her contemporaries.

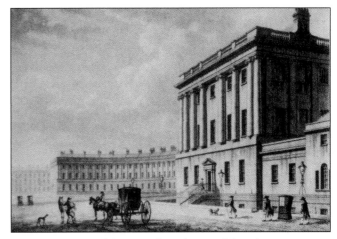

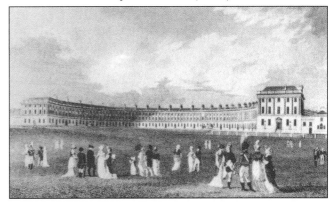

Royal Crescent from the east (above)
and from the south (below)

At the time of Jane Austen's visit to Bath, the "Crescent Fields" down to the River Avon was a popular area for informal walking, as Jane told her sister Cassandra in May 1801.

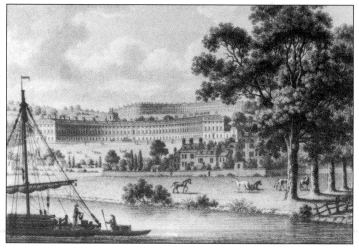

In front of the Royal Crescent, the Georgian "ha-ha" ditch remains, controlling the movement of grazing animals, and the grassed area in front of the Crescent is close to its original appearance.

The land to the west of Royal Crescent (beyond Marlborough Buildings) was part of the Common Fields, owned by the freemen of Bath. Nearly 25 years after Jane had left Bath, proposals to build on the Common Fields were rejected, and instead it was decided to lay out a public park on the land. The central area was kept open for another 50 years, but the remainder was laid out with ornamental features and a serpentine pool at the edge of a carriage drive, together with extensive tree planting. Pedestrians had free entry, but riders on horseback and in carriages paid a charge. In 1830, Princess Victoria of Kent, then aged 11 and the heir presumptive to the throne of her uncle the King, visited Bath with her mother. She agreed that the new area should be named "Royal Victoria Park".

A botanical garden was added in the late 19th century, largely based on a collection of more than 2000 specimens collected by C. E. Broome and donated by his widow. Another addition was the reputed "Lady Miller's vase". The Millers had lived in Batheaston in the 18th century, and held literary breakfasts at which participants wrote poems and put them in the vase. At a ceremony thereafter, each poem was taken from the vase in turn, read aloud, and in due course judged for a first, second or third prize. The vase, said to have been made in Italy in the 18th century, is now on display in the Park. In the 20th century tennis courts, a bowling green, a bandstand, and a golf course were added to give the park its present character.

From the Royal Crescent, Jane would have turned east along Brock Street to reach another glory of Bath, The Circus.

Built between 1755 and 1766, the three rows of houses on a circular alignment more than 100 yards in diameter surround a central area which originally was paved. The inspiration for The Circus was the Roman Colosseum, but with the buildings facing inwards.

We have seen elsewhere the importance of the springs on the hills around Bath in providing a good water supply. Springs on the slopes of Lansdown supplied a 250,000 gallon underground tank in the centre of the Circus, and also supplied the kitchens of the houses there. The springs on the northern slopes also supplied other areas on the north side of the city.

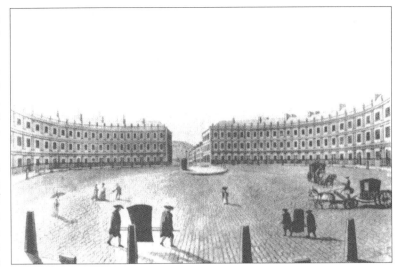

The Circus with sedan chairmen

The artist Gainsborough lived in Bath between 1759 and 1774, where he established his reputation as an outstanding portrait painter. His last home in the city was at No.17 The Circus before he left for London.

The handsome plane trees that are now such a feature in The Circus were not planted until 1790. Thus Jane Austen and her friend would have seen them in very much an immature state, and not obscuring the views across The Circus, as is the case today.

The second road from The Circus leads southwards (via Gay Street) to the north-eastern side of Queen Square, which we have already visited in our walk. But Jane and her friend would have taken the third route, eastwards along Bennett Street towards the Upper Rooms (now known as the Assembly Rooms).

Walking along Bennett Street, Jane and Mrs. Chamberlayne would have passed No19, where Arthur Philip lived.

After a career in the Navy, Philip was chosen to sail in 1787 with a fleet of convict ships to what became Australia. He chose the site of the first city at Sydney and became the Governor of New South Wales. There, he held the community together through many hardships, before retiring in 1793 in poor health. He died in Bath in 1814 and there is a memorial to him in Bath Abbey.

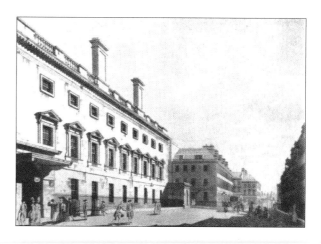

Jane Austen was familiar with the <u>Upper Rooms</u> (later called the Assembly Rooms) as they were known when she was in Bath. Built between 1768 and 1771 to accommodate the increasing number of visitors to Bath, they were mainly used for balls and gaming at cards. Subscription concerts were also held – which, bearing in mind Jane's lack of enthusiasm for such entertainments, we can assume that she did not regularly attend. The Rooms included a ballroom over 100 feet long, with a raised recess for the musicians, a card room also with a musicians' gallery, and a tea room.

The Upper Assembly Rooms - exterior (above) and interior of the Grand Ballroom (below)

During the Second World War, the Assembly Rooms were badly bombed and suffered severe damage. They were eventually restored and re-opened in 1991.

From the Upper Rooms, it was only a short stroll for Jane and her companion along Alfred Street, then southwards past Fountain Buildings to the junction with George Street opposite the York House Hotel, and then eastwards back to The Paragon.

BIBLIOGRAPHY

This book could not have been produced without reference to the many sources of information about Jane Austen and about life in Bath. The author acknowledges her debts to them, and takes responsibility for any errors.

Peter Addison,

Around Combe Down, Millstream Books, 1998.

J. Barratt and Son, and Henry Gye

The Historical and Local New Bath Guide.

Bath and Camerton Archaeological Society

A North Somerset Miscellany, 1966.

T. Boddely

Bath and Bristol Guide 1755.

Brenda J Buchanan (edited by),

Bath History - Volume VIII 2000, Bath Archaeological Trust/Millstream Books, 2000.

The Building of Bath Museum

Lyncombe and Widcombe.

Penelope Byrde

Jane Austen Fashion- Fashion and Needlework in the works of Jane Austen, Excellent Press, 1999.

Mike Chapman

A Historical Guide to the Ham and Southgate Area of Bath, The Survey of Old Bath, 1997.

Mike Chapman, John Hawkes and Elizabeth Holland,

The J Charlton Map of Lyncombe and Widcombe 1799, for the Survey of Old Bath, 1998.

Mike Chapman and Elizabeth Holland

"Bimbery" and the South-Western Baths of Bath, the Survey of Old Bath, 2001.

Gillian Clarke,

Prior Park - A Compleat Landscape, Millstream Books, 1987.

Combe Down Heritage Group

Combe Down Heritage Trail, Combe Down Heritage Group in Association with the Combe Down Stone Mines Community Association, 2002.

Kirsten Elliott,

A Window on Bath - Eight Walks in Bath, Millstream Books, 1994.

Trevor Fawcett,

Voices of Eighteenth Century Bath - An Anthology, Ruton, 1995.

Trevor Fawcett

Bath Entertain'd, Amusements, Recreations & Gambling at the 18th Century Spa, Ruton, 1998.

Trevor Fawcett,

The Bagatelle and King James' Palace: Two Lyncombe Pleasure Gardens.

Trevor Fawcett,

Bath Administer'd - Corporation Affairs at the 18th-Century Spa, Ruton, 2001.

Lesley Flash

Known at this address, Bath City Council, 1982.

Jean Freeman,

Jane Austen in Bath, Revised Edition, Jane Austen Society, 2002.

David Gadd

Georgian Summer - Bath in the Eighteenth Century, Moonraker Press, 1977.

R Gilding,

Historic Public Parks - Bath, Avon Gardens Trust/Bath & North East Somerset Council, 1997.

E L Green-Armytage,

A Map of Bath in the Time of Jane Austen.

Duncan Harper,

The Somerset and Dorset Railway - Opening of the Bath Extension, Millstream Books, 1998.

Maria Joyce and H. Mary Wills

Bath in Old Picture Postcards, European Library, 1990.

Maggie Lane,

A Charming Place - Bath in the Life and Novels of Jane Austen, Millstream Books, 1993.

Maggie Lane,

Jane Austen's England, Robert Hale Limited, 1986 - reprinted 1995.

Maggie Lane,

A City of Palaces - Bath through the Eyes of Fanny Burney, Millstream Books, 1999.

James Lees-Milne and David Ford

Images of Bath, Saint Helena Press, 1982.

Deirdre Le Faye (collected and edited),

Jane Austen's Letters - New Edition, Oxford University Press, 1995.

Brigitte Mitchell and Hubert Penrose,

Letters from Bath 1766-1767 by the Reverend John Penrose, Alan Sutton, 1983.

J W Morris (edited by),

British Association 1888 - Handbook of Bath, Isacc Pitman and Sons, 1888.

Postal Museum, Bath

John Palmer and the Mailcoach Era, 1984.

Christopher Pound,

Genius of Bath - The City and Its Landscape, Millstream Books, 1986.

Maurice Scott,

Discovering Widcombe and Lyncombe - A Short History, Revised Second Edition, Widcombe Association, 1993.

R.A.L. Smith

Bath, B.T. Batsford Ltd., 1945.

Brenda Snaddon,

The Last Promenade - Sydney Gardens, Bath, Millstream Books, 2000.

The Survey of Bath and District

No.8, November 1997 and No.15, June 2001

S. Sydenham

Bath Pleasure Gardens of the 18th Century, issuing Metal Admission Tickets, Kingsmead Reprints, 1969.

Claire Tomalin

Jane Austen - A Life, Penguin Books, 2000.

Victoria Art Gallery, Bath City Council

The Georgian Stage in Bath, 1994.

Widcombe Association

Exhibition leaflet - Rus-in-Urbe or Bath's By-Pass.

Widcombe and Lyncombe History Study Group

Proceedings - 1997 and 1999.

William Tyte,

Tales and Sketches, S. W. Simms, 1917.

William Tyte,

History of Lyncombe and Widcombe, Second Edition, H Sharp 1920.

Jane Austen was born at Steventon in Hampshire on 16 December 1775. She died at Winchester in Hampshire, aged 41, on 18 July 1817.

The novels by Jane Austen (with dates when first published) are:

Sense and Sensibility	1811
Pride and Prejudice	1813
Mansfield Park	1814
Emma	1815
Persuasion	1817
Northanger Abbey	1817